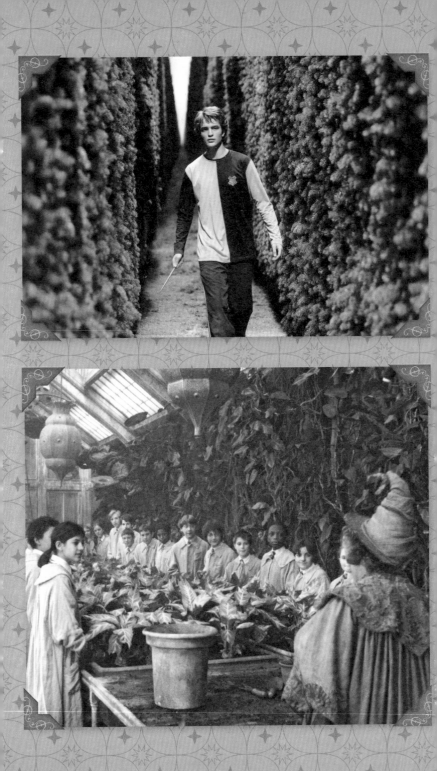

HUFFLEPUFF

One of the four houses at Hogwarts School of Witchcraft and Wizardry, Hufflepuff is named after Hogwarts founder Helga Hufflepuff, who valued loyalty, patience, and hard work. Hufflepuff's house crest features a badger, and its patron ghost is the Fat Friar.

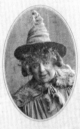

Professor Pomona Sprout

Head of Hufflepuff, Pomona Sprout also teaches Herbology classes in the greenhouses. During *Harry Potter and the Chamber of Secrets*, Professor Sprout introduced her second-year Gryffindor and Slytherin classes to Mandrakes, which would later be used to cure those petrified by the Basilisk.

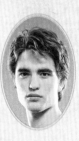

Cedric Diggory

Cedric Diggory is a Hufflepuff student two years ahead of Harry Potter. The Goblet of Fire chooses him as Hogwarts' champion during the Triwizard Tournament, and Cedric even helps Harry Potter figure out how to understand the riddle of the golden egg. Cedric is killed under Voldemort's orders at the end of the tournament.

Susan Bones

Susan Bones is the third student to be sorted during the ceremony in *Harry Potter and the Sorcerer's Stone*. After a moment of deliberation, the Sorting Hat places her in Hufflepuff. In the second film, Susan sits next to Hermione in Professor Gilderoy Lockhart's Defense Against the Dark Arts class and even attends his dueling club.

PROPERTY OF: